Royal Horticultural Society

Sharing the best in Gardening

NOTES & QUOTES

Michael O'Mara Books Limited

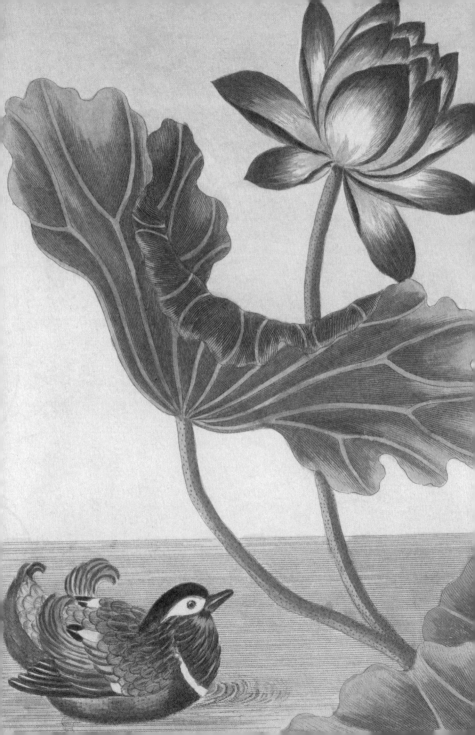

Flowers are beautiful hieroglyphics of nature, with which she indicates how much she loves us.

JOHANN WOLFGANG VON GOETHE

Plants in my book garden July 2018

Honeysuckle shrub (nondescript flowers
 red berries; plant grown hugely)
Caryopteris "Summer Sorbet" - healthy
 but no sign of the blue flowers yet.
Spiraea Looks after itself pretty well
 pretty pink flowers.
Honeysuckle climbers Planted a new
 one different flowers from the old
 (none as yet.) Expect them to mingle
Many flowering plants
Digitalis Nasturtiums Lilies.
Cosmos. Sweet william Petunias
Salvia Wallflowers ~~Begonias~~
Hollyhocks Begonias Euphorbia
Pansies Coreopsis Hellebores (8yrs)
Hydrangea Cyclamen chrysanth.
 Iris
 Fruit garden. (Back & front

Consider the lilies of the field, how they grow: they neither
toil nor spin; and yet I say to you that even Solomon
in all his glory was not arrayed like one of these.

MATTHEW 6:28–29

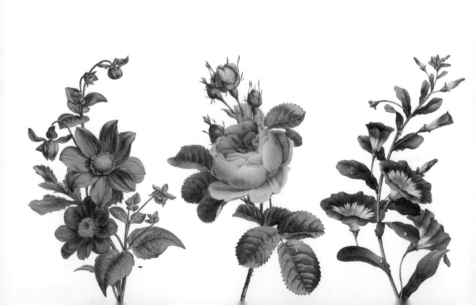

What is a weed? A plant whose virtues
have not yet been discovered.

RALPH WALDO EMERSON

My garden is my most beautiful masterpiece.

CLAUDE MONET

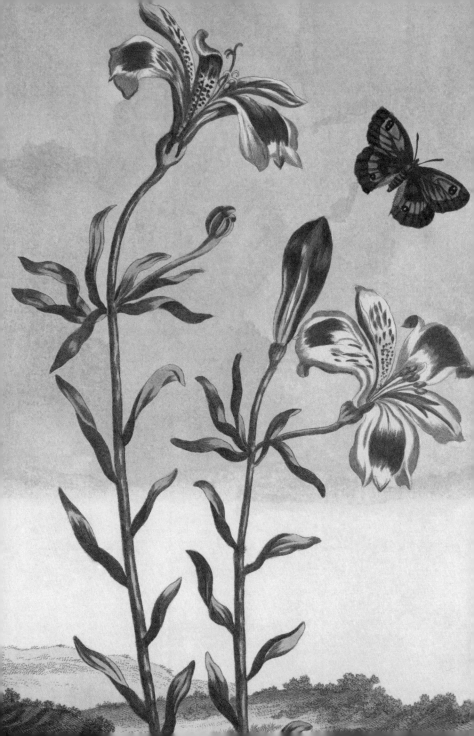

All gardening is landscape painting.

WILLIAM KENT

There is nothing much more difficult to do in outdoor gardening than to plant a mixed border well, and to keep it in beauty through the summer.

GERTRUDE JEKYLL, *WOOD AND GARDEN*, 1899

Even if I knew that tomorrow the world would go to pieces,
I would still plant my apple tree.

MARTIN LUTHER

There should be beds of roses, banks of roses,
bowers of roses, hedges of roses, edgings of roses,
baskets of roses, vistas and alleys of roses.

SAMUEL HOLE, *A BOOK ABOUT ROSES*, 1869

Perfumes are the feelings of flowers, and
as the human heart, imagining itself alone
and unwatched, feels most deeply in the
night-time, so seems it as if the flowers, in
musing modesty, await the mantling eventide
ere they give themselves up wholly to feeling,
and breathe forth their sweetest odours.

HEINRICH HEINE, *THE HARZ JOURNEY*, 1824

Who can endure a Cabbage Bed in October?

JANE AUSTEN, *SANDITON*, 1817

God Almighty first planted a garden,
the purest of human pleasures.

FRANCIS BACON

Knowledge is like a garden: if it is not cultivated,
it cannot be harvested.

AFRICAN PROVERB

Flowers always make people better, happier
and more helpful; they are sunshine,
food and medicine to the soul.

LUTHER BURBANK

Humility, and the most patient perseverance,
seem almost as necessary in gardening as rain
and sunshine, and every failure must be used
as a stepping-stone to something better.

ELIZABETH VON ARNIM,
ELIZABETH AND HER GERMAN GARDEN, 1898

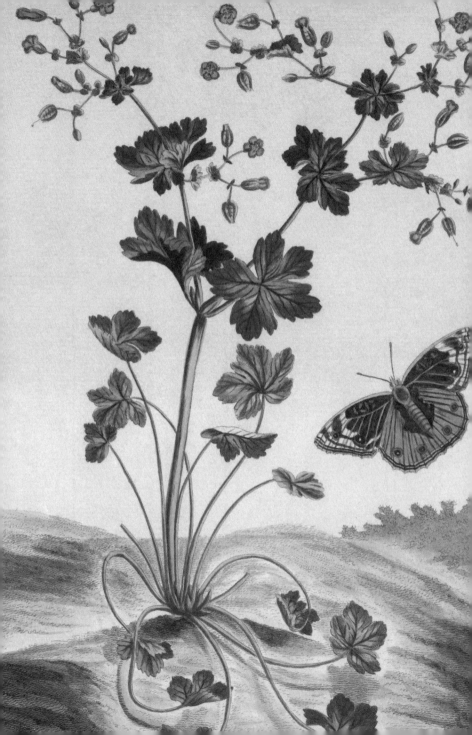

To plant a garden is to believe in tomorrow.

AUDREY HEPBURN

It is utterly forbidden to be half-hearted about gardening.
You have got to love your garden whether you like it or not.

W. C. SELLAR AND R. J. YEATMAN, *GARDEN RUBBISH*, 1936

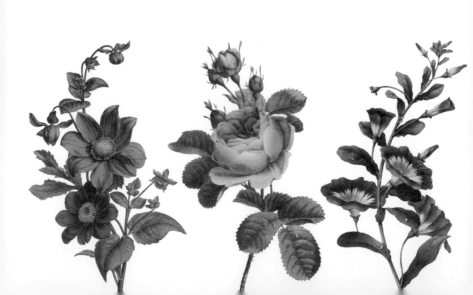

No occupation is so delightful to me as the
culture of the earth, and no culture comparable
to that of the garden ... But though an old man,
I am but a young gardener.

THOMAS JEFFERSON, LETTER TO
CHARLES WILLSON PEALE, 1811

Authorities differ as to the best way of
hoeing up a garden . . . All agree that it is
impossible to avoid walking for a week afterwards,
as if you were imitating an old waiter with lumbago.

ROBERT BENCHLEY, *INSIDE BENCHLEY*, 1942

Sweet flowers are slow and weeds make haste.

WILLIAM SHAKESPEARE, *RICHARD III*,
ACT 2, SCENE 4, 1591

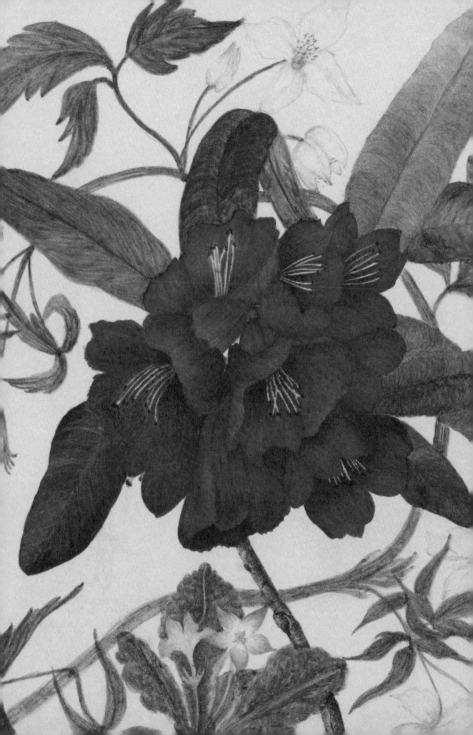

If you have a garden and a library, you have everything you need.

MARCUS TULLIUS CICERO, *EPISTULAE AD FAMILIARES*, VOL. 2, 47–43 BC

Fair dewy roses brush against our faces,
And flowering laurels spring from diamond vases;
O'erhead we see the jasmine and sweet briar,
And bloomy grapes laughing from green attire.

JOHN KEATS, 'I STOOD TIP-TOE
UPON A LITTLE HILL', 1817

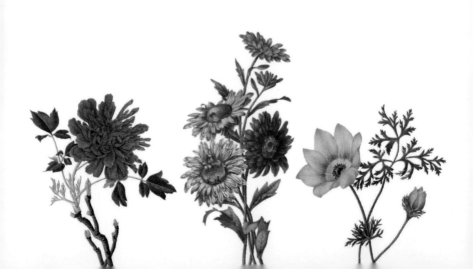

'But it is not enough merely to exist,'
said the butterfly. 'I need freedom, sunshine,
and a little flower for a companion.'

HANS CHRISTIAN ANDERSEN,
'THE BUTTERFLY', 1861

What a desolate place would be a world
without a flower! It would be a face without
a smile, a feast without a welcome.

CLARA LUCAS BALFOUR

We can complain because rose bushes have thorns,
or rejoice because thorn bushes have roses.

ABRAHAM LINCOLN

When rosy May comes in wi' flowers,
To deck her gay, green-spreading bowers,
Then busy, busy are his hours,
The gard'ner wi' his paidle.

ROBERT BURNS, 'THE GARDENER'S MARCH', 1789

Gardens are not made by singing 'Oh, how
beautiful!' and sitting in the shade.

RUDYARD KIPLING, 'THE GLORY OF THE GARDEN'

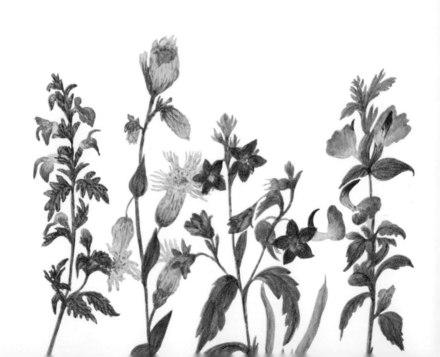

Designing a landscape is about connecting
the body, soul and mind to the land itself.

KATHRYN GUSTAFSON

In search of my mother's garden,
I found my own.

ALICE WALKER, *IN SEARCH OF
OUR MOTHERS' GARDENS*, 1972

Botany – the science of the vegetable kingdom,
is one of the most attractive, most useful, and most
extensive departments of human knowledge. It is,
above every other, the science of beauty.

JOSEPH PAXTON, *PETER PARLEY'S
CYCLOPEDIA OF BOTANY*, 1838

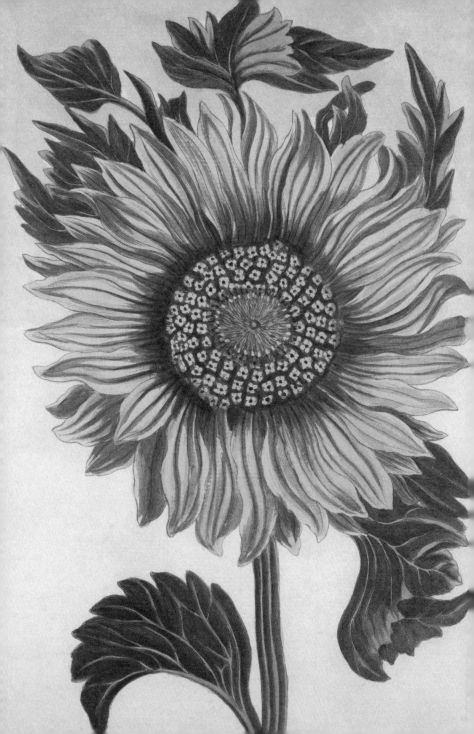

The way of cultivation is not easy.
He who plants a garden plants happiness.

CHINESE PROVERB

Where you tend a rose, my lad, a thistle cannot grow.

FRANCES HODGSON BURNETT, *THE SECRET GARDEN*, 1911

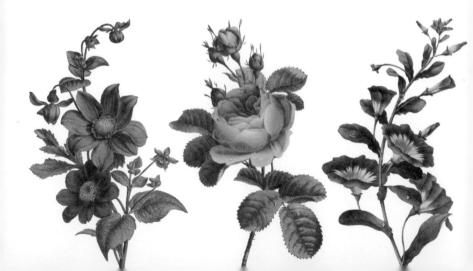

Half the interest of the garden is the constant
exercise of the imagination.

MRS C. W. EARLE

How fair is a garden amid the toils
and passions of existence.

BENJAMIN DISRAELI

The glory of gardening: hands in the dirt,
head in the sun, heart with nature. To nurture a
garden is to feed not just the body but the soul.

ALFRED AUSTIN, 1896

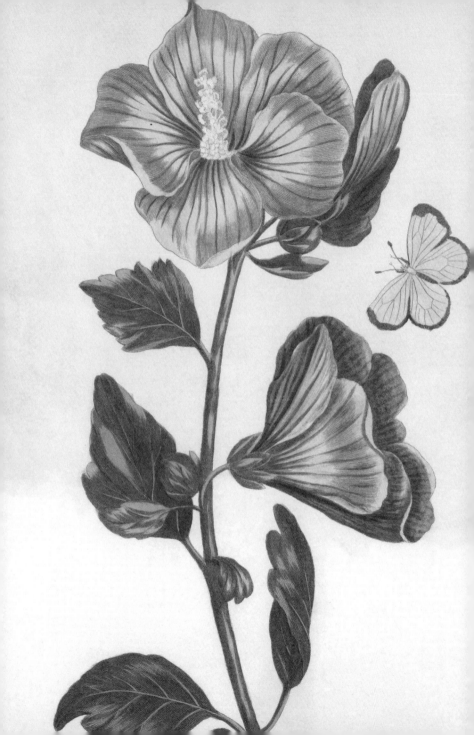

A gardener's work is never at an end;
it begins with the year, and continues to the next;
he prepares the ground, and then he sows it; after
that he plants, and then he gathers the fruits . . .

JOHN EVELYN, *KALENDARIUM HORTENSE*, 1706

As the garden, so the gardener.

HEBREW PROVERB

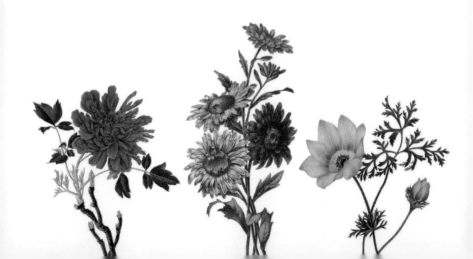

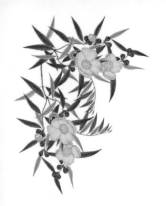

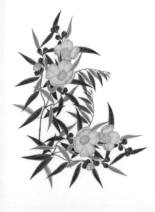

The more help a man has in his garden,
the less it belongs to him.

W. H. DAVIES

A real gardener is not a man who cultivates flowers;
he is a man who cultivates the soil . . . He builds
his monument in a heap of compost. If he came
into the Garden of Eden he would sniff excitedly
and say: 'Good Lord, what humus!'

KAREL ČAPEK, *THE GARDENER'S YEAR*, 1929

A garden isn't meant to be useful. It's for joy.

RUMER GODDEN, *CHINA COURT*, 1961

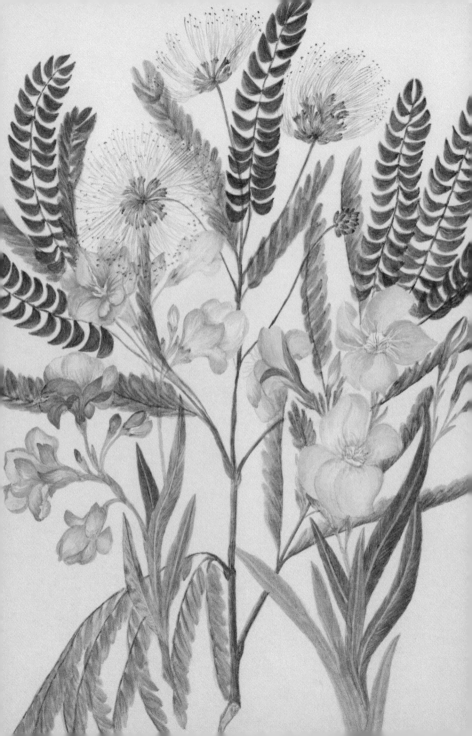

You need to walk a garden at all times of the day
and seasons and watch the light, the way it hits a leaf
with a particular texture or filters through . . . You adjust
and move plants to enhance that experience. You have
to use your eye the way an artist does.

BEVERLEY McCONNELL, *WALL STREET JOURNAL*, 2013

Flowers have an expression of countenance
as much as men or animals. Some seem to smile;
some have a sad expression; some are pensive and diffident;
others again are plain, honest and upright, like the
broad-faced sunflower and the hollyhock.

HENRY WARD BEECHER, 'A DISCOURSE
OF FLOWERS', *STAR PAPERS*, 1855

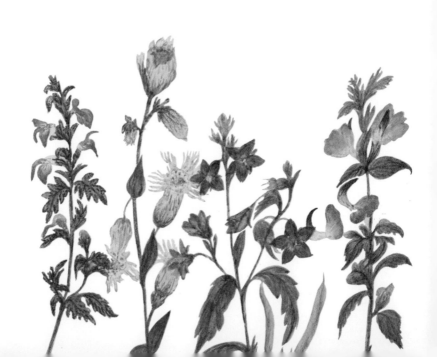

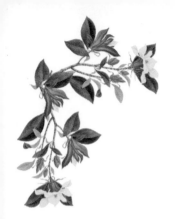

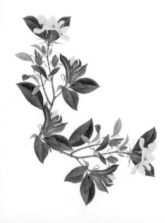

Nothing is more the child of art than a garden.

SIR WALTER SCOTT

In dry weather, observe to water all the plants
as have been lately transplanted, and be sure to always
do this in the evening; for one watering at that time
is of more service than three at any other time of
the day . . . the moisture having time to penetrate
the ground before the sun appears to exhale it.

PHILIP MILLER, *THE GARDENERS KALENDAR*, 1760

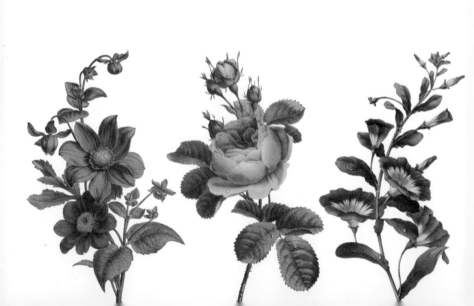

The rose looks fair, but fairer we it deem
For that sweet odour which doth in it live.

WILLIAM SHAKESPEARE, SONNET 54

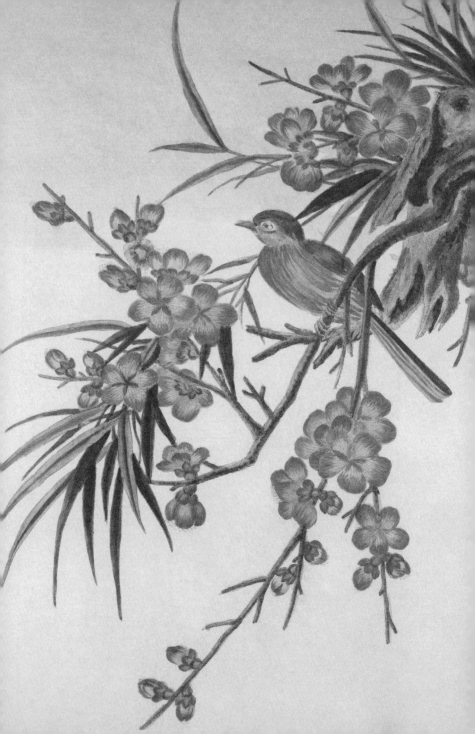

The kiss of the sun for pardon,
The song of the birds for mirth,
One is nearer God's heart in a garden
Than anywhere else on earth.

DOROTHY FRANCES GURNEY, 'GOD'S GARDEN', 1913

If I do live again I would like it to be as a flower –
no soul but perfectly beautiful. Perhaps for my
sins I shall be made a red geranium!

OSCAR WILDE

Dilettante gardeners love the spring and summer;
real gardeners also love the winter.

ANNE SCOTT-JAMES, *DOWN TO EARTH*, 1971

To a gardener there is nothing more exasperating
than a hose that just isn't long enough.

CECIL ROBERTS, *THE NEW YORK TIMES*, 1951

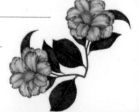

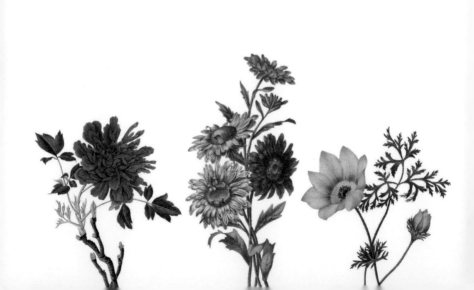

A good book is like a garden carried in the pocket.

ARAB PROVERB

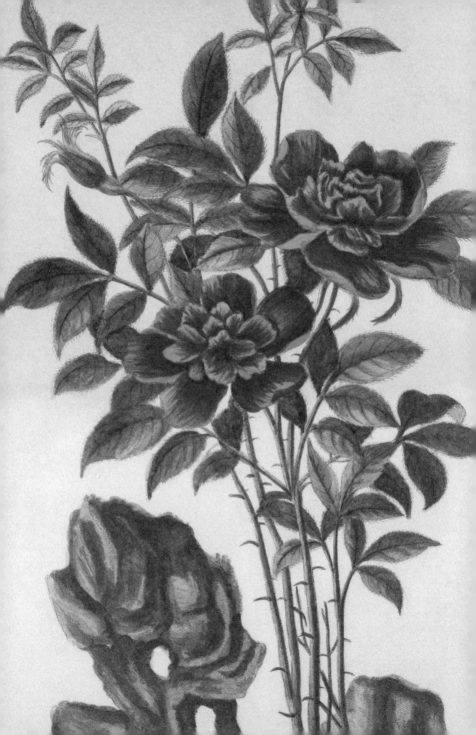

A man of words and not of deeds is like a garden full of weeds.

AMERICAN PROVERB

Don't judge each day by the harvest you
reap, but by the seeds that you plant.

ROBERT LOUIS STEVENSON

'Tis the last rose of summer,
Left blooming alone;
All her lovely companions
Are faded and gone.

THOMAS MOORE, 'THE LAST
ROSE OF SUMMER', 1805

The love of gardening is a seed
once sown that never dies.

GERTRUDE JEKYLL

A weed is but an unloved flower.

ELLA WHEELER WILCOX

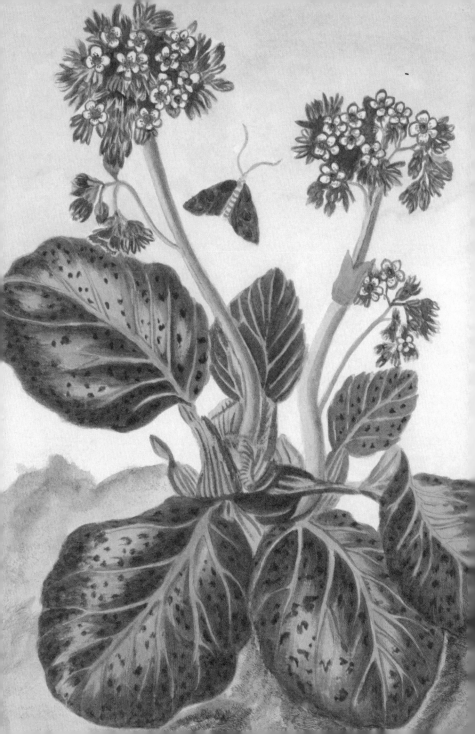

If you would be happy for a week take a wife;
if you would be happy for a month kill a pig; but if
you would be happy all your life plant a garden.

CHINESE PROVERB

Nature abhors a straight line.

WILLIAM KENT

If you have but two coins, use one for bread to feed
the body and the other for hyacinths to feed the soul.

PERSIAN PROVERB

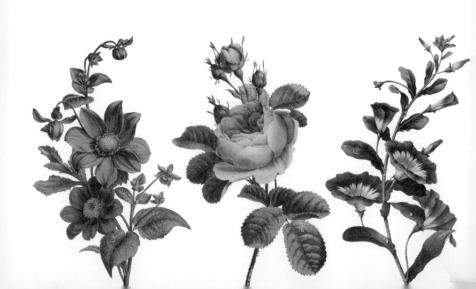

A garden to walk in and immensity to dream in –
what more could he ask? A few flowers at his
feet and above him the stars.

VICTOR HUGO, *LES MISÉRABLES*, 1862

The bad gardener quarrels with his rake.

AMERICAN PROVERB

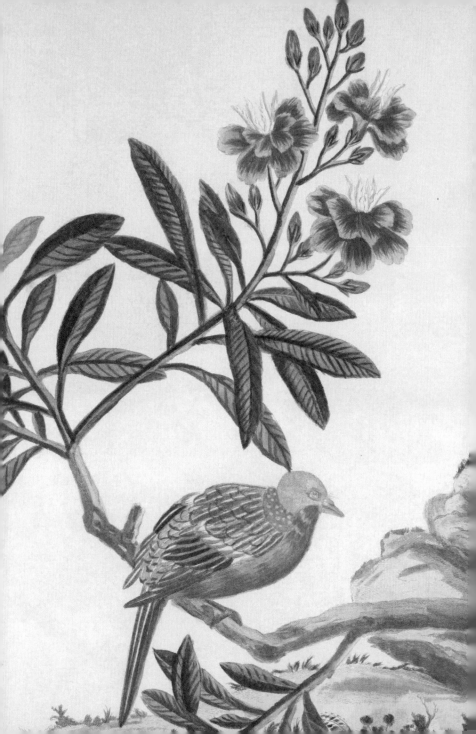

A flower blossoms for its own joy.

OSCAR WILDE, LETTER, 1890

In joy or sadness flowers are our constant friends.

OKAKURA KAKUZŌ, *THE BOOK OF TEA*, 1906

Show me your garden and I shall tell
you what you are.

ALFRED AUSTIN, 1896

Do not spread the compost on the weeds.

WILLIAM SHAKESPEARE, *HAMLET*,
ACT 3 SCENE 4, 1603

First published in Great Britain in 2016 by
Michael O'Mara Books Limited
9 Lion Yard
Tremadoc Road
London SW4 7NQ

A CIP catalogue record for this book is available from the British Library.

ISBN: 978-1-78243-572-3

1 2 3 4 5 6 7 8 9 10

www.mombooks.com

Designed by Ana Bjezancevic

Printed in China